TIDE MILLS
OF
SOUTHERN ENGLAND

ALEX VINCENT

AMBERLEY

This edition first published 2024

Amberley Publishing
The Hill, Stroud
Gloucestershire GL5 4EP

www.amberley-books.com

British Library Cataloguing in Publication Data.
A catalogue record for this book is available from the British Library.

ISBN 978 1 3981 1682 5 (print)
ISBN 978 1 3981 1683 2 (ebook)

Typesetting by SJmagic DESIGN SERVICES, India.
Printed in Great Britain.

CONTENTS

INTRODUCTION

Producing flour from corn first occurred in the Neolithic period, when people started to farm the land instead of being hunter-gatherers. The corn was crushed in hollows in rocks to make flour. After this, stones were used to grind corn. This process probably took place in their settlements. In the Neolithic period there were saddle querns, where a saddle-shaped block and a smaller stone such as a pebble was used to grind corn into flour.

Next came the rotary quern, which was first recorded in the Iron Age. This is a two-stone system where the upper (runner) stone was revolved by hand over the base (bed) stone, with the corn passing between the two surfaces and emerging at the sides as flour. A reproduction of this method can be seen and used in preserved mills. A number of museums have a collection of saddle and rotary querns. Both of the above hand mills were used (and in some countries still are used) domestically to produce flour for the family's daily bread. Later, larger quantities of flour and animal feeds were produced communally on farms and possibly at milling centres.

Watermills date from the Roman period, and the Anglo-Saxons were great watermill builders. The first water-powered mills, known as Norse or Greek mills, appeared around 85 BC. These were mills with a horizontal wheel, whereas mills with a vertical wheel powered by water from a stream or river were designed between 20 and 11 BC by the Roman engineer Vitruvius.

A great number of mills were recorded in the Domesday Book (1086), such as one at Gomshall, near Shere, in Surrey. There were no windmills in Britain at the time of the Domesday Survey, so all recorded mills were either water, tidal or animal powered. Watermills were built by a stream or tributary of a river, and some on the actual river, to harness the water. A millpond was built by them. The Domesday mills would have been smaller than the later watermills built on the same site.

An animal-powered mill is sometimes used in conjunction with a watermill or windmill. Horses were popular for this, but other animals were also used such as dogs, donkeys, camels and oxen. Horse mills were frequently used for grinding grain and pumping water. A treadwheel was powered by humans.

Another type of mill was boat or ship mills, which were floating mills. These were very common in Europe and were situated on large rivers like the Danube, Rhine and their tributaries. They weren't many in Britain, though an attempt was made to have some on the River Thames in London. Some existed in Southwark, but were gone by the early nineteenth century.

A number of watermills were also used for other purposes. Paper mills, for example, were devoted to make paper from vegetable fibres like wood pulp, old

rags and other ingredients. A fulling mill was a watermill that fulled cloth (mainly sheep's wool) and used fulling stocks instead of millstones. Another was the gunpowder mill, which made gunpowder using saltpeter. Sawmills cut timber into lumber. Textile mills were used for spinning yarn or weaving cloth.

Windmills were built to harness the wind. They date to seventh-century Persia, but were not introduced to Britain until the twelfth century. The windmill at Iford, near Lewes in Sussex, may be the earliest recorded windmill in Britain. An entry from the Testa de Nevill, dated 1155, states: 'Hugo de Plaiz gave the monks of Lewes the windmill in his manor of Iford, for the health of the soul of his father.' This would have been situated on Iford Hill.

Windmills come in three types: post, tower and smock. The former has a central post where the whole mill revolves to face the wind. In the case of tower and smock mills, only the cap revolves to face the wind and they have a fantail. Post mills had a roundhouse built round them, but some were left open. Medieval windmills were smaller and were open trestle sunken post mills. Some medieval windmills were built on Bronze Age barrows and the roundness of the barrow was used as its base. The later eighteenth-century windmills were probably built on the same sites as earlier medieval ones.

By the beginning of the fourteenth century there were some 10,000 mills in Britain, most of which were watermills. Mills (particularly windmills) were a prominent feature in the British landscape between the eighteenth and nineteenth centuries. There were around 250 windmills in and around Brighton, Sussex, and it is said that you could not see the town for its windmills.

A great number of watermills and windmills went out of use during the nineteenth and twentieth centuries. Many were demolished and a number of windmills were blown or burnt down. The dusty flour in the closed atmosphere of a mill is very flammable, especially dangerous when combined with the usual wooden structure of most mills. A great number of mills are now in use as homely dwellings and there are many that have been restored to their former glory, with some producing flour again. Some examples in southern England are at High Salvington Windmill, Sussex and the City Mill watermill in Winchester, Hampshire.

A tide mill or tidal mill is a watermill that was worked by harnessing the ebb and flow of the sea. They were situated on tidal river estuaries, creeks and inlets of water, away from the waves but near enough to the sea. A tide mill comprises of a mill, outbuildings, a dyke, dam or causeway and millpond beyond. Tide mills are usually built on causeways, which are situated in the upper reaches of a river estuary.

When the tide comes in, the millpond behind the dam is filled with seawater by a one-way gate. When the tide starts to go out, the sea gate closes and impounds the water, which is used to work the mill. Milling took place for between four or five hours from each tide. This means that millers who worked on tide mills had to work unsociable hours because they had to go with the tides. A tide mill was a reliable source of power.

Tide mills date from Saxon times, but some tide mills could possibly go back to the Roman period. The earliest one may have been located on the River Fleet in London. A Roman watermill (possibly a tide mill) was discovered during the construction of the A259 Rustington Bypass near Littlehampton in West Sussex.

In recent times, the date of the earliest tide mills have been pushed back further by archaeological finds.

At Killoteran, near Waterford in Ireland, a vertical-wheeled tide mill was found dating to the seventh century AD. The tide mill at Nendrum Monastery on Mahee Island in Strangford Lough, Northern Ireland, is the oldest tide mill to be excavated. It is dated to AD 787. The remains of an earlier tide mill, dating to AD 619, were found lying beneath it. This earlier mill is the world's oldest known tide mill.

Most tide mills are now gone, but some can still be traced today as ruins, scanty remains and earthworks. Some are in use as some other function, such as homely dwellings. In some cases, just the millpond survives – wholly or partly. Some tidal millponds are now in use as a nature reserve, marina or yacht basin.

In some cases, timber, bricks and tiles were used in other buildings. Machinery was removed too, possibly for reuse in other mills. One example of this is a crane that was at Wootton Tide Mill on the Isle of Wight but is now in use in Bembridge Windmill. Millstones may have also been taken to other mills, while others were sold for use as garden ornaments.

There are only three tide mills in working order that produce flour in the UK today: at Eling, near Southampton in Hampshire; Woodbridge, near Ipswich in Suffolk; and at Carew Castle in west Wales. Other tide mills that can operate are at Rupelmonde in Belgium, with more in Spain and Portugal. Tide mills are being restored and some are open to the public. One example is the House Mill on Three Mills Island in Bromley by Bow, East London; it is the largest remaining tide mill in the world and worked twelve pairs of millstones. This mill was mentioned in the Domesday Book of 1086. The name 'Three Mills Island' is from two tide mills and a windmill. The latter is now gone but the second tide mill, known as Clock Mill, is still standing and is in use as offices.

It is said that Chichester Harbour has the largest concentration of tide mills in the country. There were ten, and most of them were in Sussex. Two of them were

Woodbridge Tide Mill, Suffolk.

in Hampshire at Emsworth and Hayling Island. Although the mills at Bosham and Cutmill, Chidham are near creeks, they are actually watermills. The mill at Langstone near Havant, Hampshire, is sometimes mistaken for a tide mill, but this is actually a watermill fed by the Lymbourne Stream. It is tidal restricted.

The Thames in London was tidal enough to have tide mills as far as Battersea on both sides of the river. None of these survive today, but others on tributaries still exist. It is possible that other tide mills could have existed further west up to Staines. One of these may have been the Upper Mill on the River Wandle at Wandsworth, but this is more likely to have been harassed by the tide rather than harnessed by it.

Many former mills now only exist today as names such as Mill Hill, Mill Farm and Windmill Hill. Other indications are Mill Road, Mill Lane or field names on old maps. In the case of Mill Road and Mill Lane, this means that a mill existed in those roads or that the roads led to the mill. These lost mills either show no sign of their former existence or there may be remains, such as ruins or simply earthworks where they once stood. A good number of artefacts from these mills – like millstones – can be seen in existing mills and museums.

This book gives details about the tide mills that existed in southern England between the counties of Hampshire and Kent. It will outline their history, age and what remains (if any) are still to be seen. There are no tide mills still standing in Kent today. The old Flood Mill at Deptford was rebuilt as a steam flour mill, where only the Mumford's Mill still stands. That at Faversham became Twymans Mill, which still stands today and is now a block of flats. The areas that are now part of London but were originally in Kent, such as Greenwich and Deptford, are also included. The tide mill at Birdham in Sussex is the only one still standing in Sussex. The tide mill at Eling, near Southampton in Hampshire, is the only tide mill working in the area and is open to the public.

All photographs were taken by the author unless otherwise stated.

Bromley-by-Bow House Mill, East London. The clock mill can be seen to the right.

Tide mills in Hampshire

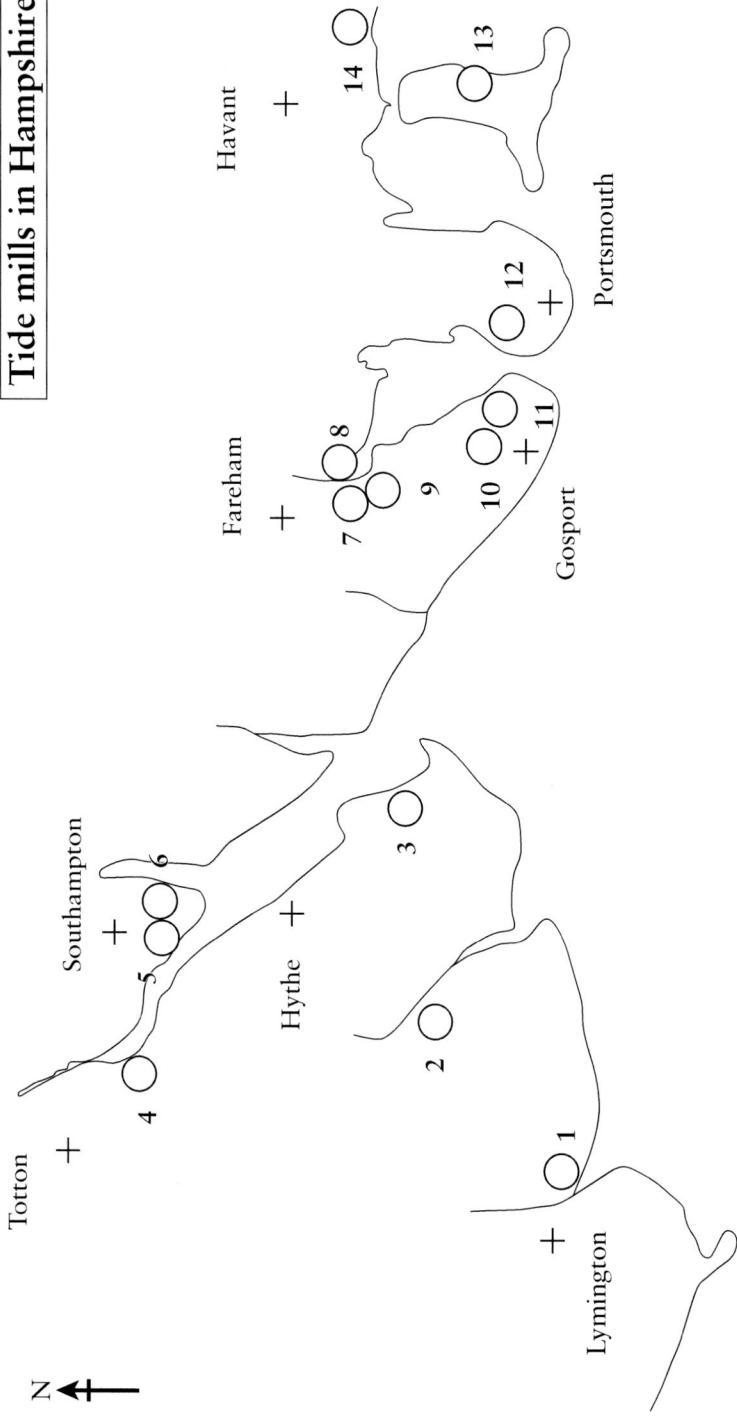

1. Lymington
2. Beaulieu
3. Ashlett
4. Eling
5. Southampton: God's House Tower Mill
6. Southampton: Chapel Mill
7. Fareham: Seamill or Bishops Mill
8. Fareham: Cams Mill
9. Fareham: Hoc or Hockford Mill
10. Gosport: Forton Mill
11. Gosport: Weevil Mill
12. Portsmouth: Kings Mill
13. Hayling Island
14. Emsworth: Quay Mill

Totton

Southampton

Hythe

Havant

Fareham

Portsmouth

Gosport

Lymington

N

HAMPSHIRE

ASHLETT

OS Grid Reference: SU 466 032

The former tide mill at Ashlett, near Fawley, was built in 1618 and the present building dates from *c.* 1816. This date is on a stone on the east side of the building. The mill is situated at the head of Ashlett Creek on Southampton Water, and the millpond is to the north. It is a brick-built building of four storeys and has eight bays. Ashlett Creek was a commercial wharf and at one time was owned by the Cadland Estate.

Ashlett Tide Mill showing its arches.

Ashlett Tide Mill situated on the creek.

Millstone found in a nearby garden now inside Ashlett Tide Mill.

The tide mill ceased working in 1902, and a survey in 1907 suggested that the millpond was disused. There is no machinery in the mill today. The mill race arches and the sluice remain. The tide mill is now the Waterside Sports and Social Club. In 2013, a millstone was found in a nearby garden, which is now in the mill.

BEAULIEU

OS Grid Reference: SU 387 023

Beaulieu Tide Mill dates from the sixteenth century and it was let to Henry Wells by the 3rd Earl of Southampton in 1573. The main mill structure is a two-and-a-half-storey brick weatherboarded building. There were originally two waterwheels in the mill, each with two sets of stones. It was later converted to a turbine with one waterwheel being used as an oil engine. The tide mill was built on a causeway that spans the Beaulieu River in Beaulieu High Street.

The tide mill was closed in 1942 and still stands today, but it was in a poor condition by 2000. In 2006, a fire partially destroyed it. The roof and first

The brick and weatherboarded Tide Mill at Beaulieu.

floors were badly gutted. The tide mill underwent major restoration in 2011, with new foundations, structural timbers, insulation, rewiring and the roof areas were re-tiled. At present the mill is not in use but it is complete for letting to a commercial tenant – largely offices. It is not open to the public.

ELING

OS Grid Reference: SU 365 125

Eling (part of Totton) was mentioned in the Domesday Book as 'Edlinges', where a church, two mills at 25s, a salt house and fishery are recorded. Both of these mills may have been tidal. The tide mill at Eling was obtained from the Crown by the Bishop of Winchester, William de Wykeham, in the fourteenth century. In 1382 he endowed the mill to Winchester Collage. The collage leased the mill; for example, it was leased to Thomas Myddleton (Mayor of Southampton 1401–03) in 1418.

The present tide mill was rebuilt in the eighteenth century and is situated on an ancient causeway across Eling Creek, at the north-western end of Southampton Water. It is a building of two and a half storeys and had two Poncelet waterwheels, which each drove two pairs of stones. There is a keystone dated 1755, which indicates that the culvert to the penstock was rebuilt. The tide mill is on a toll bridge, where rights to charge tolls here go back to at least the fourteenth century. The tide mill was marked on eighteenth- and nineteenth-century maps. The millpond is to the south of the mill, which is empty at low tide if the sea gates are open.

The tide mill was a thriving business during the Victorian era and the early twentieth century. The Phillips family leased the mill for most of the nineteenth century; a member of this family, W. Phillips, was vicar of Eling Church from 1805 to 1855. Joseph Soffe was miller in the 1850s. Philip Stride took the business over and employed George Mackrell as the miller. The latter's son, Sydney, helped to collect the tolls. Sydney married Alice Weaver in 1885 and they had fourteen children. One of these, Tom Mackrell, was the last miller of Eling Tide Mill. He died in 1893.

The tide mill closed in 1946, except for the taking of tolls. In 1975 the mill and associated property was sold to New Forest District Council (NFDC). The Eling Tide Mill Trust was formed to restore and manage it. It was opened as a working mill and museum on 1 May 1980 by Angela Rippon. At the time of its opening, it was possibly the only working tide mill in the world. It has been producing flour regularly since, but it closed in 2015 to undergo further restoration and refurbishment. It was reopened in 2018 and rebranded as the Eling Tide Mill Experience.

A building that adjoins the tide mill was once used for the Eling grain store. It is now used by the Eling Sailing Club. The wooden hut to the south of the tide mill is a tollkeeper's shelter. Eling is owned by NFDC and managed by the

Eling Tide Mill by a toll bridge and tollhouse.

The workings inside Eling Tide Mill.

The remains of the old waterwheel in Eling Tide Mill.

Aerial view of Eling Tide Mill. (David Plunkett Collection)

Eling Experience under the Totton and Eling Town Council. The former trust was closed in 2009.

EMSWORTH: QUAY MILL

OS Grid Reference: SU 748 055

Emsworth Quay Tide Mill was built in the 1760s and worked four pairs of stones. It enclosed a tidal creek with a small undershot wheel. The mill is a three-storey brick-built building to the south of the town. It has a large millpond. It is thought that the mill was built to produce flour for biscuits during the French wars.

 In an auction of 1816, the tide mill is referred to as having three pairs of stones, situated on the quay of Emsworth Harbour, together with two cottages, an extensive storehouse and a capacious bakery with two ovens, a cart house and stables. The waterwheel became disused when a steam engine was installed in 1883. Main gearing was removed and a roller milling plant installed.

Emsworth Quay Tide Mill, now in use as a yacht club.

The large tidal pond of Emsworth Quay Tide Mill.

The tide mill ceased working in the early 1920s. The undershot wheel has been removed and only two of the millstones remain. The building is little changed. The southern end of the lagoonal millpond has a promenade for public use. The Slipper Sailing Club purchased the mill in 1974 and is in use today. The store building north of the tide mill is now a café called Flintstones Tearoom.

FAREHAM: CAMS MILL

OS Grid Reference: SU 587 062

Fareham is mentioned in the Domesday Book as 'Ferneham', where a church and five mills with a total value of 41s are recorded. One of these mills was the tide mill called Wallingford or Cams Mill. It was situated on the north-eastern part of the Fareham Creek. The Bishop of Winchester held this mill, and others, locally in the fourteenth century.

Cams Tide Mill was mainly a wooden building with a tiled roof. This building dates largely from the seventeenth century. The Goodeves family worked it in the eighteenth century, together with nearby Wallington Windmill. The Delme family (who the mill was later passed to) had let the mill to tenant millers until the mid-nineteenth century.

The mill closed as a working tide mill in the early twentieth century and was demolished in the 1920s, leaving no remains. A plaque by the bridge on the main road (the A27) states: 'Two mills harnessed the sea for Fareham and elsewhere for 900 years.' In 2012, a brand-new public house was built, replicating the tide mill near the site. It looks as authentic to the original as possible, even the culverts. It opened as a pub called Cams Mill in November 2013.

Fareham Cams Tide Mill. Watercolour by Matin Snape (1874–1901). (Image from the Mills Archive Trust)

Fareham Cams Tide Mill. Modern mill built as a pub near the site of original tide mill.

Fareham Cams Tide Mill. The site of the original is to the left.

FAREHAM: HOC MILL

OS Grid Reference: *c.* SU 580 046

The Hoc Tide Mill is one of the mills mentioned in the Domesday Book entry for Fareham. It is also known as 'Hockford Mill'. Its exact location is on the alignment of the main road to Gosport where the underground stream from HMS Collinwood comes out under the road. It is just south of the Hoeford Inn. This pub has since closed and it is now in use as a day nursery. This mill was in operation during the Middle Ages and had ground corn in smaller quantities than the other Fareham tide mills. The mill was lost by the mid-sixteenth century.

This area was known as 'Hock Forde' on Thomas Phillips' map of 1678. Hoeford is the most likely site of the tide mill. There is a dip in Gosport Road (A32) near the old Hoeford Inn, where the creek came up to. Other possible sites were thought to be at Hook, near Warsash, which was an important

Possible site of Fareham Hoc Tide Mill near the old pub.

port at one time. Hook village was in a deep flooded valley. Hook House on Titchfield Common is another possibility.

Fareham: Seamill

OS Grid Reference: SU 608 005

The seamill at Fareham was another tide mill featured in Domesday. It is also known as 'Bishop's Mill' and 'Tyde Mill'. The mill had been pulled down in 1585 but its name was transferred to the Cams Mill site. It was succeeded by a public house in the seventeenth century, which had since been displaced. The tide mill was fed by the Black Brook as well as the tide.

The tide mill was situated at Lower Quay, to the south of Fareham, on the east side of the A32 main road. On the site today is an industrial building called Fairweather Marine, which is an outboard and rib specialist. The millpond is now much smaller and is in use as a meadow pasture. There is a direct link between two of the Fareham tide mills and Portsmouth Tide Mill (King's Mill) in history.

Site of Fareham Seamill Tide Mill.

GOSPORT: FORTON MILL

OS Grid Reference: SU 608 005

The tide mill at Forton in Gosport dates from the seventeenth century. It was rebuilt as an adjunct to Chapel Common Windmill in the 1740s. The windmill dates from the late seventeenth century. The tide mill is marked on the 1841 tithe map, which shows a millpond of 21 acres. The mill ceased as a working mill by 1840. There was a causeway and wharf, which was owned by James Phillip in 1841.

Part of St Vincent's College is on the site today, and the causeway is now Mill Lane. There are two modern marker stones in Jervis Drive, which mark the site of the millpond (now filled in). This lane follows part of the south bank of the millpond, and Mill Pond Road is the north bank of the millpond. It is possible that there was an early tide mill in Gosport (site now lost) at Stoke Lake.

Site of Gosport Forton Tide Mill with a millstone by the roadside.

Gosport Weevil Tide Mill.

GOSPORT: WEEVIL MILL

OS Grid Reference: SU 618 006

This tide mill was part of Royal Clarence Victualling Yard (Weevil Mill), which was built in the eighteenth century as part of a large range of Admiralty buildings. It is possible that a victualling yard existed on the site previously. In the early nineteenth century, the tide mill became a steam mill, which contained flour mills and a bakery. It was marked on an 1841 tithe map as plot No. 358, Weevil Mill, Admiralty.

The mill closed sometime in the mid-twentieth century and became the property of the MOD for a time. The mill has been converted into flats and apartments today and the site is also used commercially with other buildings in the vicinity. The mill building itself is known as 'The Flour Mill' and has four storeys. The area is part of the Royal Clarence Victualling Yard.

HAYLING ISLAND

OS Grid Reference: SU 726 012

Hayling was mentioned in the Domesday Book as 'Halingei', but no church or mills were recorded. There was a tide mill at Hayling in medieval times, which

Site of Hayling Tide Mill – the warehouse may have been part of the mill.

was recorded in the twelfth century. It was valued at £3 in 1294. It is not known if this mill (the Priory Mill) survived the sequestration of the estate in 1415. The inventory of Hayling Priory mentions another mill in 1325, which was a windmill.

The present tide mill was built in the mid-eighteenth century and possibly had three pairs of millstones in 1813. It was associated with a quay, which was capable of taking 40-ton vessels. The tide mill was rebuilt in 1876 by Mr E. Padwick. The tide mill is situated on the eastern side of Hayling Island in an area called Mill Rythe.

The tide mill was destroyed by fire in January 1877. On the site today is a red-brick building, which may have been part of the old tide mill. Part of the embankment, which drained the millpond, can be seen at low tide. The pond area is now part of the Hayling Yacht Club and the mill quay as commercial units. In the early twentieth century, an attempt was made to extract gold from seawater here, but it was unsuccessful.

LYMINGTON

OS Grid Reference: *c.* SZ 327 957

Lymington is mentioned in the Domesday Book as 'Lentune', but no church or mills were recorded. The tide mill site at Lymington, dating from the seventeenth century,

was in use as salterns. The later millpond is shown on a map of *c.* 1680, but not the mill – it may not have existed at this time. A 1661 deed conveys the site of the millpond and nearby salterns on a 2,000-year lease with an annual rent of 1*d*.

The tide mill came out of use and was demolished in 1868 when the Brockenhurst to Lymington Railway was built. The site of the tide mill is now at the southern edge of a new housing development, just east of the railway line to Lymington Ferry. The mill granary site was south of the station yard. In the 1880s, the millpond area was used in association with a sawmill. The area was used for industry and warehousing when the pond was filled in. The area east of Lymington Town station is now housing.

PORTSMOUTH: TOWN MILL

OS Grid Reference: SZ 634 998

The tide mill at Portsmouth dates from the Middle Ages and provided flour for the Royal Navy. The Portsmouth King's Mill was granted to Thomas Beeston in 1575, and by 1714 it was purchased by the Crown. The tide mill was small and was replaced by a larger building in 1744. The tide mill had burnt down in 1868 and nothing remains today as the area is now built over. There was a direct link with this tide mill and some of the Fareham tide mills via Thomas Beeston.

Portsmouth Tide Mill was situated east of Gun Wharf and had a large millpond east of St George's Road. The site of the millpond is now a sports ground for the United Services Recreation Ground. An earlier tide mill or watermill existed prior to King's Mill, which was situated to the east. Nothing of this earlier mill survives today. Watermills did not seem to have been a practical proposition in the town. Portsmouth had a number of windmills, which are all now gone.

SOUTHAMPTON: CHAPEL MILL

OS Grid Reference: SU 430 115

Southampton is mentioned in the Domesday Book as 'Hantone', but no church or mills are recorded. The Southampton Chapel Mill in St Mary's parish dates from the early thirteenth century due its proximity to the twelfth-century Trinity Chapel. The earliest surviving document regarding this mill mentions a windmill (Chapel Mill) standing 'between the sea and the marsh' about ¼ mile away. This windmill must have stood along the shingle spit.

Chapel Mill was enlarged in the sixteenth century and driven by two ponds, which were formed by the enclosure of a lagoon. It was marked on a late sixteenth-century map as a tide mill. A fulling mill once existed nearby on the small fresh water stream in the sixteenth century, which is the only one recorded in the Southampton area at that time. The tide mill was rebuilt in 1740 and may have used stones from the Trinity Chapel, which was disused by this time.

Site of Southampton Chapel Mill, now built over by modern development.

It was originally thought that there were two mills on the site due to the appearance of a double pond. This was only a single pond and a causeway was built across it. The tide mill came out of use around 1838 and it was demolished in 1960. Nothing remains of the tide mill or millpond today. The site is under the former Town Council Depot and has largely been redeveloped north of the old Crossing House. The area is now known as Chapel Side.

SOUTHAMPTON: GOD'S HOUSE TOWER MILL

OS Grid Reference: SU 421 109

This tide mill dates from the late thirteenth century, but the mill may not have been functional as the head of water (in the moat) may have been too low. It was built at the seaward end of the east walls and defensive ditch, which was controlled at high tide by a sluice gate. The water in the ditch may not have been adequate for a watermill and so the mill would have used the tide. A late sixteenth-century map of Southampton depicts a shingle spit in the vicinity.

The tide mill was installed in God's House Tower. This was a stone-built barbican dating to the thirteenth century. It commanded the moat at the seaward

Southampton God's House Tower Tide Mill – note the blocked-up arch.

end of the medieval walls. The millpond was lost when the Southampton to Redbridge Canal was built in the late eighteenth century. The tower still remains, but the moat and mill have long gone. The relieving arch above the tail race is still visible, which is now bricked in.

POSSIBLE TIDE MILLS IN HAMPSHIRE

There could be many more tide mills in southern England waiting to be discovered. Many of the mills mentioned in the Domesday Book near the coast may have been tidal, but it does not state how they were worked. Modern archaeologists have identified early mill sites, but there is no evidence that any were tidal. Some of them probably were, particularly those on or near river estuaries, inlets and creeks.

There could be many more former tide mills in Hampshire, waiting to be discovered. The Solent was rich in tide mills. The Domesday Book mentions twenty-nine mills in the area, some of which may have been tidal. These mills would have been either watermills, tide mills or animal-powered mills as no windmills existed in Britain at that time. Some were more likely intermediate mills, restricted by higher tide levels.

A tide mill may have existed at Warblington on Chichester Harbour. The mill mentioned in the Domesday Book (when Warblington was returned as part of Westbourne in Sussex) is believed to have been a tide mill, located east of the church dedicated to St Thomas Becket. This could have been a tide mill as the sea

would have been closer to the village in the Middle Ages and it also had a creek. It could also have been a watermill as a stream exists here as well (like at nearby Langstone). There are no signs of the mill to be seen today and the millpond is visible in a field to the east of the church and castle as a large dip.

Havant is mentioned in the Domesday Book as 'Havehunte', where two mills valued at 15*s* and three salt houses valued at 15*d* were recorded, but no church. One or both of these mills may have been tidal. The later mill at Havant was a watermill. Other possible sites in the Havant area may have been at Brockhampton and Bedhampton. Both of these places are mentioned in the Domesday Book where mills were recorded. Were any of these tide mills?

Another possible site is at Portchester on Portsmouth Harbour. Portchester is mentioned in the Domesday Book as 'Porcestre', where three mills with a total value of 5*s* 30*d* are recorded. One or two of these mills could have been tidal as a creek comes up to the village. The area just north of the Saxon Shore Fort may have been its site, and the large green area may have been the site of its millpond.

Redbridge, near Southampton, was mentioned in the Domesday Book as 'Betametune', where a mill valued at 15*s* is recorded. Was this mill tidal? Further north the village of Nursling was mentioned in the Domesday Book as 'Notesselinge', where a mill valued at 22*s* and 8*d* was recorded. This may also have been a tide mill. Milford on Sea, south-west of Lymington, was mentioned in the Domesday Book as 'Melleford' where a mill valued at 30*d* was recorded. Was this mill tidal?

Site of Warblington's Domesday Mill, which may have been tidal. The millpond is represented by a dip in the field.

Tide mills on the Isle of Wight

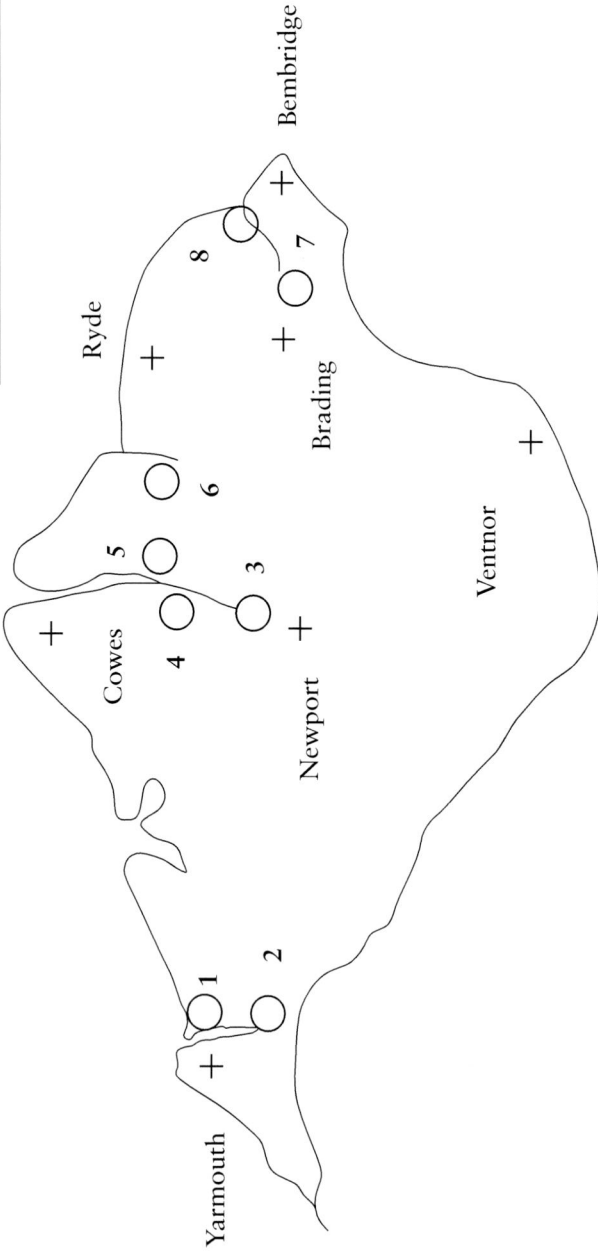

N

Yarmouth

Cowes

Newport

Ventnor

Ryde

Brading

Bembridge

1
2
3
4
5
6
7
8

1. Yarmouth
2. Freshwater
3. Newport
4. Cowes: West Medina

5. Cowes: East Medina
6. Wootton Bridge
7. Brading
8. St Helens

Isle of Wight

Brading

OS Grid Reference: *c.* SZ 616 868

A tide mill once existed at Brading, but there are few details about it. Its first reference was in the seventeenth century, in the notes on Sir Hugh Myddleton: 'In 1620 began reclaiming from the sea, a flooded area known as Brading Harbour.' This means that the mill was probably destroyed by 1629. St Helen's Tide Mill in Bembridge Harbour replaced it at a later date.

The location of Brading Tide Mill is at the junction of several streams, and a few old footpaths also meet at this point. One of the footpaths may have been a trackway that led to the mill. Nearby fields are known as 'Mill Fields'. The unclaimed land was underwater at high and mid tide, and the millpond probably was made by the sea walls. There are no signs of the tide mill to be seen today. A sluice exists in the area. The area to the west is known as 'Mill Mead'.

Cowes: East Medina

OS Grid Reference: SZ 508 919

East Medina Tide Mill, near Binfield, was built by William Porter in 1790, possibly on the site of a thirteenth-century mill. It was a large mill and was one of the greatest of the British tide mills. The Reach family owned the mill until it closed in 1939. It had a low breastshot wheel, which once stood in a wheelhouse outside the mill.

The tide mill has since been demolished, and on the site today are sections of the concrete sea wall and the large millpond. There were remains of the pit and waterwheels from the mill embedded in the sea wall. No machinery survives on the site today. The site is now a marina called Island Harbour, which is set in a most picturesque riverside location. A white octagonal tower stands on the site of the tide mill. This is the lock control for the harbour.

Site of Cowes East Medina Tide Mill.

COWES: WEST MEDINA

OS Grid Reference: SZ 504 915

The tide mill at West Medina was also built by William Porter. It dates from the eighteenth century and is on the site of a medieval mill. It was not a success like his East Medina Tide Mill. It was not fully operational, as William Porter got into trouble and a financial crisis broke his efforts in 1793. The tide mill was taken over as a medical unit and barracks in 1799. Charles Francis took the mill over in 1840 and began producing Medina cement. This meant that the mill did function for some other purpose. The mill was closed in 1944. Only the millpond remains on the site today. The tide mill was situated on the west side of the Medina River, north of Dodnor Farm.

Site of Cowes West Medina Tide Mill.

FRESHWATER

OS Grid Reference: *c.* SZ 348 872

Freshwater is mentioned in the Domesday Book as 'Frescewatre', but no church or mills are recorded. The date of the construction of the tide mill at Freshwater is uncertain, and there are not many details about it. An engraving by W. H. Bartlett and T. Baber of *c.* 1805 shows the road crossing the River Yar where the tide mill once stood.

There are no details of the mill's demolition, but it probably occurred in the nineteenth century. It is shown as a ruin on the first edition of the 6-inch OS maps. It probably ceased working as a tide mill due to the silting up of the millpond and sea inlet known as 'The Mill Dam' (now a causeway). Nothing can be seen of the tide mill or millpond today.

Site of Freshwater Tide Mill on the River Yar.

NEWPORT

OS Grid Reference: *c.* SZ 502 895

There was once a tide mill at Newport; it dates from the late seventeenth century. It was referred to in a lease dated 1728 and is marked on an eighteenth-century map. With no useful stream in the area and the provision of a dam, this suggests that the mill was a tide mill. It was known as 'Mill on the Ooze'. The area was marshy wetland in medieval times and known as the Woas, Oase or Ooze. It covered brackish water at high tide. The tide mill ceased to exist by 1792, and there are no signs of it to be seen today. A field named 'Mill Close' existed in the area. The site of the tide mill is somewhere where the Riverside Café now stands on the west side of the Medina River, north of the bridge. This river was also known as Newport River. The name Medina is from the Old English *meoune*, which means 'the middle one'. It was known as Medine in 1196. The river is in the middle part of the Isle of Wight.

Café on the site of Newport Tide Mill.

St Helens

OS Grid Reference: SZ 632 887

The tide mill at St Helens, near Bembridge, dates from the eighteenth century and replaced the one at Brading. It is situated at the head of Bembridge Harbour and has a large millpond to the east. It was an L-shaped stone-built mill with a slate roof and was three storeys high. It was a trading mill and had a large seaborne trade, the only tide mill on the Isle of Wight to be wholly dependent on the tide. The others were also associated with streams.

The tide mill was owned by the Way family during the nineteenth century. The mill closed sometime in the twentieth century. In 1969 it was demolished and the remains were converted into a house with millstones in the front garden. The millpond is in two parts, bisected by a causeway with footpath. The inner pond was possibly the original millpond and extended when a second wheel was added.

House built on the site of St Helens Tide Mill and the millpond.

WOOTTON BRIDGE

OS Grid Reference: SZ 547 920

Wootton is mentioned in the Domesday Book as 'Odetone', but no church or mills are recorded. Wootton Bridge Tide Mill dates from the twelfth century and was owned by Quarr Abbey. The earliest record was in 1132, stating that 'the mill at Shaldflete (Wootton Bridge) with all its mulcture in the Manor of Wootton'.

The tide mill was reverted back to the estate of the de Lisles after the Dissolution of the Monasteries by King Henry VIII in the sixteenth century. It was a brick building with a tiled roof. The mill was on the north side of the Newport to Ryde road and the large millpond on the south side. It was also fed by the Blackbridge Brook. The mill dam is the causeway, which carries the road.

Wotton Bridge Tide Mill came out of use sometime in the mid-nineteenth century, and a survey of 1863 shows that it was disused. The building was

Wootton Bridge Tide Mill. (Courtesy of the Mills Archive Trust)

Site of Wootton Bridge Tide Mill.

Crane in Bembridge Windmill from the Wootton Bridge Tide Mill.

The millpond at Wootton Bridge Tide Mill.

demolished in 1962 and on the site today are yacht men's cottages. The old millhouse is now The Sloop Inn. There is a plaque on the site and the area is now Mill Square. A crane, millstones and other relics from the tide mill are now in use in Bembridge Windmill. The latter is the only remaining windmill still standing on the Isle of Wight and is open to the public.

YARMOUTH

OS Grid Reference: SZ 356 894

The tide mill at Yarmouth was probably built as a wooden building sometime in the 1660s, possibly on the site of sea mills of 1284. The mill causeway was constructed in 1664 in order to seal off Thorley Haven, probably to form a millpond. The present tide mill was built by William Porter in 1793.

This tide mill is a four-storey brick building on a stone base and has a slate roof. It has six bays, and the southern ones were the millhouse. The tide mill became steam powered by about 1845. A single-storey boiler house existed at the north-east corner of the mill, which housed a steam engine. The base of the chimney still survives. There is a chimney at the southern end of the tide mill.

The tide mill closed in the early twentieth century and by the 1901 census it was unoccupied. The mill is now in use as holiday accommodation and the exterior

Yarmouth Tide Mill, now holiday accommodation.

Yarmouth Tide Mill.

is unaltered. The millpond is completely silted up and the Freshwater Railway crossed it on a viaduct and embankment. It is thought that this viaduct may have reduced flow into the millpond, which added to the tide mill having been closed.

POSSIBLE TIDE MILLS ON THE ISLE OF WIGHT

A number of other tide mills may have existed on the Isle of Wight in medieval times. There may have been earlier tide mills on or near the sites of the later ones. The northern section of the Isle of Wight is suitable for tide mills where there are a few inlets, which may have worked tide mills and so others may be discovered in the future. The southern section seems to be mainly cliffs, where tide mills may not be likely.

One possible site is at Wilmingham between Yarmouth and Freshwater on the River Yar. Wilmingham is mentioned in the Domesday Book as 'Wilmingeham' but no church or mills are recorded. The site of this mill would have been situated to the west of the hamlet on the River Yar. The footpath from Wilmingham towards the river may have been the trackway that led to it.

A tide mill may have existed at Yaverland near Brading. Yaverland was mentioned in the Domesday Book as 'Evreland', where a mill is recorded valued at 12s. This mill may have been tidal as there are no streams at Yaverland. It would have been situated on the northern end of the inlet, which ran down from Richard's Great Sluice towards Yaverland Manor.

The inlet near Shalfleet at the western end of the Isle of Wight may also have had a few tide mills at one time. Shalfleet was mentioned in the Domesday Book as 'Seldeflet' where a mill valued at 11d and a church is recorded. Could the Domesday mill have been tidal? The existing mill was a watermill, which is now a homely dwelling.

Site of the possible tide mill at Wilmingham on the River Yar.

Tide mills in Sussex

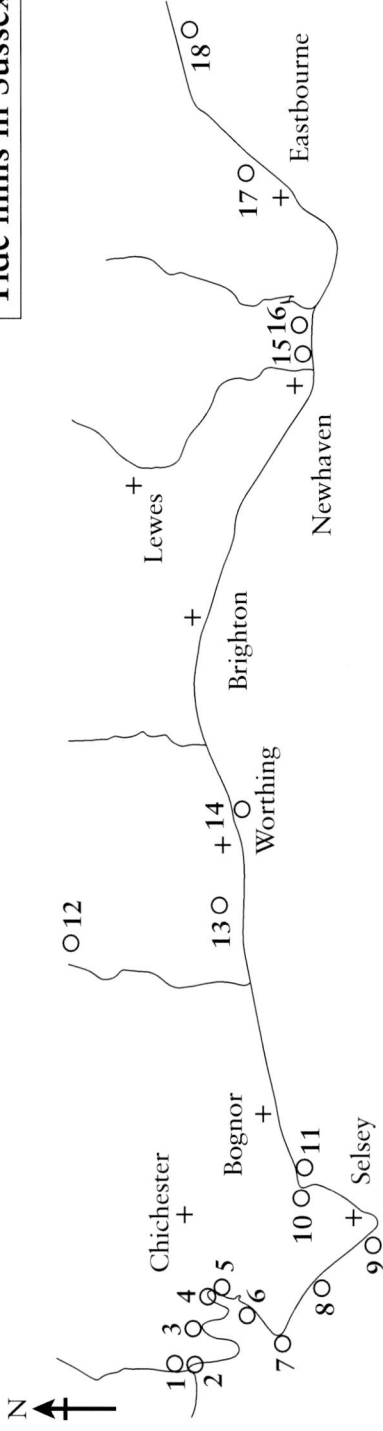

N

Chichester
Bognor
Selsey
Worthing
Brighton
Lewes
Newhaven
Eastbourne

1. Emsworth: Old Slipper Mill
2. Emsworth: New Slipper Mill
3. Nutbourne
4. Fishbourne: Old Salt Mill
5. Fishbourne: New Salt Mill
6. Birdham
7. West Wittering

8. Bracklesham
9. Selsey
10. Sidlesham
11. Pagham
12. Wepham
13. Rustington
14. Worthing: Seamill

15. Bishopstone Tide Mills
16. Seaford
17. Langley
18. Normans Bay

Sussex

Birdham

OS Grid Reference: SU 824 011

Birdham, on Chichester Harbour, was mentioned in the Domesday Book as 'Brideha', where a mill at 20*s* was recorded. This mill was a tide mill and is one of many on the harbour. It was rebuilt on the same site in 1768 and again in 1891. It is a timber building. The tide mill had five pairs of stones and two waterwheels. One of the latter was inside the building.

An old painting of Birdham Tide Mill with the initials 'GHJ'. Artist and date unknown. The building could be an old warehouse associated with the tide mill. (High Salvington Mill Trust Collection)

Birdham Tide Mill. (Bob Bonnet Collection)

Birdham Tide Mill on Chichester Harbour.

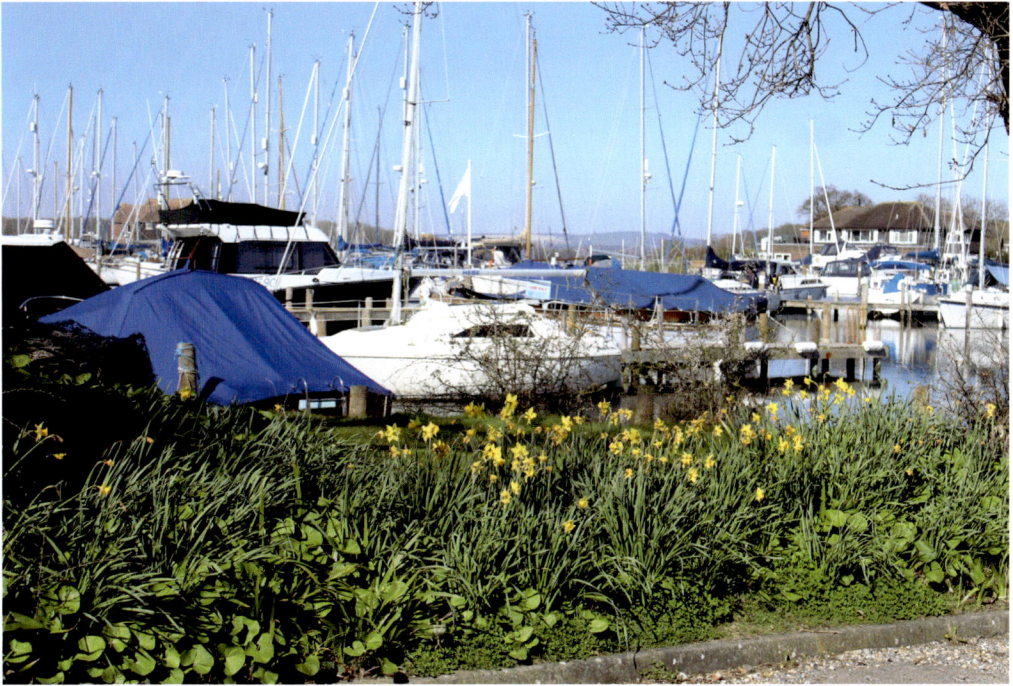

Birdham Tide Mill millpond.

The mill ceased working in 1935 and was the last tide mill to be functioning in Sussex. All its machinery (except the upright shaft and waterwheels) were removed in 1936. The timber building still stands today and its millpond was partly converted into a marina. This was used to repair and build naval boats in the Second World War. The tide mill is a private house called The Old Mill and is not now part of the marina. The area today is known as the Birdham Pool Waterside and Marina.

BISHOPSTONE TIDE MILLS

OS Grid Reference: TQ 459 002

The tide mills at Bishopstone between Newhaven and Seaford were erected in 1761 as a corn mill. The mills were operated by a reservoir, which was formed by damming the creek. It was also fitted with sluices. Large areas of marshland were drained and earthen banks were constructed. The Mill Creek, which was fed by the River Ouse, is situated to the west of the mills going towards Newhaven.

The Bishopstone Tide Mills worked sixteen pairs of stones, which were variously driven by three undershot waterwheels. The tide mills were able to produce 1,500 sacks of flour each week. There was a sixteen-hour day, which

involved two hours before low tide, twelve until the next and two hours after. Grinding took place for four or five hours during each low tide.

In the nineteenth century, cottages, a blacksmith, carpenter shops, mill offices, a granary, a large barn and a small outhouse were built here. This turned the tide mills into a village, which developed as a community under the influence of William Catt. He built a windmill on top of the granary at this time, which was used for hoisting. Tide Mills had a population of about 100. Sidings from the adjacent railway were built to the village.

In 1876 a violent flood occurred and water poured across the village, flooding it and homes were destroyed. The mill closed in 1883. Tide Mills also suffered from the sea breaking through in 1912/13, and a number of cottages were destroyed in the First World War. The population was sparse by the end of the war.

After the First World War part of the village of Tide Mills was taken over by Dales Racing Stables, which moved out in the 1930s. The Chailey Heritage Beach Hospital for disabled children was built at the southern end, but due to the threat of a German invasion in the Second World War the remaining population was evacuated. This was the end of the village of Tide Mills.

On the site today are the ruins of the village. These include the brick arches that went under the tide mill, the barn and foundations of the Chailey Heritage Hospital, plus others. A siding with track still exists on the site. There are plaques that provide details of the history of Tide Mills, and the millponds are a nature reserve. A group known as the Tide Mills Project helps to keep the site preserved.

Bishopstone Tide Mill in its heyday with the windmill on top, which was used for hoisting grain. (Courtesy of the Mills Archive Trust)

The arches beneath the old tide mill at Bishopstone.

Remains of the tide mill at Bishopstone.

BRACKLESHAM

OS Grid Reference: *c.* SZ 800 960

A tide mill once existed at Bracklesham on the Manhood Peninsula. There is a reference in the Chichester Chartulary dated 6 April 1298 stating that the 'Prebendary of Thorneye [East Thorney now lost to the sea by coastal erosion] that Mr. Henry may build a watermill on his prebendal land'. The Victoria County History (VCH) states to 'build a watermill on the existing millpond'. This mill was valued at 20s in 1340. The existing millpond mentioned by the Victoria County History may suggest that there was an earlier mill on the site that was a tide mill. This tide mill has now gone and was lost to the sea by coastal erosion. No sign of it can be seen today at low tide. The millpond has silted up.

EMSWORTH (SOUTHBOURNE): NEW SLIPPER MILL

OS Grid Reference: SU 753 054

Emsworth in Hampshire had three tide mills, and two of these were over the border in Sussex, in the parish of Southbourne. They were known as New Slipper and Old Slipper mills. The origin of the name 'Slipper' is obscure, but it is thought to have come from the Old English word *slyppe*, which means 'mud' and 'sand'.

Millpond and site of the New Slipper Mill, Emsworth, Southbourne.

The New Slipper Tide Mill was built in 1865 by Andrew Hatch. It was south of the Old Slipper Mill and lasted for around thirty years before it got burnt down in 1897. This tide mill was not commercially viable and could not develop its full power. An attempt had been made to power the tide mill by steam just before it burnt down.

There are little remains of the tide mill today, apart from traces of old brickwork. The millpond, called Big Bunny, was filled with tree trunks in 1959. Part of the millpond has been filled in, but most of it still survives and it became a yacht basin and yard for Emsworth Marina in the 1960s. The area is called Mill Quay today.

EMSWORTH (SOUTHBOURNE): OLD SLIPPER MILL

OS Grid Reference: SU 753 054

This tide mill was built in the mid-eighteenth century and situated at the southern end of Slipper Road. It was a corn mill, which worked two pairs of stones, and the water drove the undershot wheel under the mill for some five hours at each tide. It continued to work as a tide mill until 1849. After this date, the mill was used for storage. Most of the tide mill was demolished in the 1960s and all that remains today are the base walls with arches and the storehouse. The latter was converted into four houses in 1970. The large millpond, known as Slipper Millpond, also survives and is an attractive habitat for migrating birds in the winter.

Remains of the Old Slipper Mill, Emsworth.

Old Slipper Mill, Emsworth, *c.* 1910. (Bob Bonnet Collection)

Culverts for water overflow from the waterwheels of the Emsworth Old Slipper Mill.

The Slipper Millpond of Emsworth (Southbourne) Old Slipper Mill, now in use as a nature reserve.

Site of Fishbourne New Salt Mill and pathway leading to it.

FISHBOURNE: NEW SALT MILL

OS Grid Reference: SU 838 040

This tide mill was adjacent to Fishbourne Old Salt Mill and worked in conjunction with it. It stood on the opposite side of the creek to the east. It was built by John Jeliffe in the late eighteenth century. The millpond was known as 'Farhill's Pond'. Salt Mill is named from the salt workings that existed in the area.

The tide mill came out of use sometime in the nineteenth century and was demolished. In the mid-twentieth century some signs of masonry still existed, but very little remains today. The site is represented by a slight mound, and a curved path going towards it was probably a track to the tide mill.

FISHBOURNE: OLD SALT MILL

OS Grid Reference: SU 836 041

Fishbourne was mentioned in the Domesday Book as 'Fisebourne', where two mills at 40s were recorded. These were probably the Saltmyll (a tide mill) and the

Fishbourne Old Salt Mill in its heyday. (Bob Bonnet Collection)

Remains of Fishbourne Old Salt Mill Tide Mill – exposed at low tide.

Causeway to the Fishbourne Old Salt Mill Tide Mill.

Freshmyll. The latter was not tidal because it was fed by the Fishbourne Stream. Three mills were listed in 1460: Freshmyll, Lityl Saltmill and Seamyll.

The tide mill known as the Old Salt Mill is some 300 yards south of Fresh Mill. It was marked on Richard Budgeon's map of 1724. The building was built of red-coloured stone and had a tiled roof. The mill was in an exposed position. The Sheppard family owned the mill in the late nineteenth and early twentieth centuries. The route to the mill was by a curved causeway. The large millpond was to the west of the causeway.

The mill was burnt down in the winter of 1917. All that remains today are foundations, brick culverts and traces of a tail race. These are visible at low tide. The causeway is now a path, which can only be walked along at low tide. The millpond still exists with marshland and is an important nature reserve.

LANGNEY

OS Grid Reference: *c*. TQ 630 010

Langney, between Eastbourne and Westham, was mentioned in the Domesday Book as 'Langelie', but no church or mills were recorded. A tide mill is thought to have existed at here. A mid-twelfth-century charter of Lewes Priory states 'that the

water of the sea may have free ebb and flow and passage to their mill of Langeneya through my marsh which is neighbouring to the same mill'. This statement seems to suggest that it was a tide mill, which would make it the oldest recorded tide mill in Sussex.

It is uncertain where the tide mill stood, which was some 250 yards south of Langney Priory. The latter dates from the twelfth century. The area around Langney Bridge may have been the site, as there was once a tidal inlet here. No lagoons seem to have existed and there is no mention of field names on the Westham tithe map to suggest its location. A slight mound with bushes at the junction of Sevenoaks Road and Langney Drive may have been its site or it may have been further east, where it is now built over.

Normans Bay

OS Grid Reference: TQ 688 057

There was once a tide mill at Normans Bay to the east of Pevensey. It was marked on Greenwood's map of 1825 and situated at the southern end of the Waller's Haven. The site of the tide mill today is either on land where a dip exists, which may have been the millpond, or lost to the sea by coastal erosion.

Possible site of Normans Bay Tide Mill on the Waller's Haven.

The tide mill probably utilised the arrangements of the Waller's Haven, which flows through the garden of the Star Inn to the north. This pub was built in 1402 and the flow of the water was controlled by the people who lived there. The pub was once a sluice house. The millpond was within the Hooe Level.

NUTBOURNE

OS Grid Reference: SU 777 049

Westbourne was mentioned in the Domesday Book as 'Bourne' where six mills, with a total value of 60s, and two churches are recorded. Some of these mills may have been tidal. One of these mills may have been the one at Nutbourne and would have used the Ham Brook. In 1320, a valuation meant that the mill 'sometimes stood still for want of water'. This mill became a tide mill in the eighteenth century and had a very large millpond. The mill was also large and drove six pairs of stones. The Miller family owned it in the mid-nineteenth century. The tide mill

Site of Nutbourne Tide Mill and millpond.

Plaque at Nutbourne on the sea defence wall, which provides details about the history of the tide mill.

ceased to be a working mill sometime in the 1890s. On the site today are a few bricks from the mill visible at low tide, and the millpond is now marshland. There is a plaque about the tide mill on the wall of the sea defences on the site.

PAGHAM

OS Grid Reference: *c.* SZ 884 972

Pagham is mentioned in the Domesday Book as 'Pageham', where a church and mill valued at 10s are recorded. The mill is probably a tide mill, which was situated due south of the church. In the thirteenth century, the Custumals states that 'Master Richard de Pageham holds two mills'. The tide mill was described as 'Tyde Myll containing a corn mill and a malt mill'.

The tide mill's last reference was in 1607 when its site was among the vicar's source of income. The tide mill probably came out of use sometime in the seventeenth century and was demolished soon after. The millpond or mill creek is now Pagham Lagoon, which is a nature reserve. Pagham Lagoon is a tidal estuary. There are no signs of the tide mill to be seen today.

Rustington

OS Grid Reference: TQ 046 038

During the construction of the A259 Rustington Bypass in the 1990s, traces of a Roman watermill was discovered. This dates from the second century AD.

Roman millstones from Rustington Tide Mill on display in Littlehampton Museum. (Courtesy of Littlehampton Museum)

This was probably a tide mill, which would have used the tidal Black Ditch between Rustington and Poling. The Black Ditch is now just a stream. A number of ditches were dug along the bypass. The excavations recovered millstones and quern stones dating to the Roman period, which are now on display in Littlehampton Museum. There is nothing to be seen on the site today as the bypass has obliterated most of the tide mill. It was situated north of Penfold Lane. A slight dip in a field to the west of the lane and south of the bypass may have been the millpond. This area floods in wet weather.

'Nonneminstre' was mentioned in the Domesday Book, where a church, two salt houses and a mill valued at 40*d* are recorded. This place was at one time thought to have been an alternative name for Lyminster, but it is now thought to be West Preston, near Rustington. Could the Domesday mill have been the Rustington Tide Mill?

SEAFORD

OS Grid Reference: *c.* TV 471 995

A tide mill existed at Seaford south-east of the village of East Blatchington in the thirteenth century. In the same century, Robert Peuerell gave God and St Pancras and the monks of Lewes 'land beside the mill of Sefford upon which the pond of the mill is established'. A causeway was built to it, which was called 'Poghemill in Bletchington'. This said causeway was probably a highway.

The tide mill was located by the marsh and would have been near the easterly deflected River Ouse. The mill was removed in the first quarter of the fourteenth century and there are no remains to be seen today. The area was once part of a large a tidal inlet and is marked as 'The Salts' on the 1874 OS map. The area is now a nature reserve called The Old Brickfield, but there is only slim evidence that there was once a brick-making industry on the site.

SELSEY

OS Grid Reference: SZ 861 972

A tide mill once existed at Selsey in medieval times. This was situated on the western shore in the area, known as 'Medmerry'. In 1522 it was mentioned that the sea end of the harbour was partly blocked and was converted into a millpond for a tide mill. It was leased for 40*s*. Thomas Farringdon farmed the mill in 1640.

The tidal pond was partly washed away by the sea in the mid-eighteenth century. The tide mill was replaced by a windmill further inland in the same century. This is a tower mill, which still stands today with all four sails.

Part of the former tidal pond at Selsey. Medmerry Windmill is in the distance.

The low-lying land south-west of the windmill is all that remains of the large millpond, which is now silted up. This is marked as 'Millpond Marsh' on the 1839 Selsey tithe map.

SIDLESHAM

OS Grid Reference: SZ 861 972

This tide mill dates from the medieval period and there are several references to it in the manorial custumals of 1275. It is marked on the Spanish Armada map of 1587 as 'Sedlesham mille. unto whiche a Barke of 40 tonne maye flete'. The millpond is depicted on the map. The tide mill is situated on Sidlesham Quay on Pagham Harbour in Mill Lane.

In 1755 the timber-framed building was replaced by a larger building by Woodruffe Drinkwater. Sidlesham was a commercial port, so cargoes of coal and

Sidelsham Tide Mill after the addition of the steam engine and the reclamation of Pagham Harbour. (Bob Bonnet Collection)

Remains of Sidelsham Tide Mill today.

grain were brought to the mill by boat. The boats left with cargoes of flour. The mill had three waterwheels and eight pairs of stones.

The tide mill was converted to steam after 1876 due to the reclamation of Pagham Harbour. It was closed in 1900 and was demolished for its bricks in the First World War. On the site today is a rectangle of grass with low brick walls, which are the only remains of the tide mill. On the other side of the road is the millpond, which was much larger at one time. The houses in the vicinity are eighteenth-century cottages, known as Mill Hamlet.

WEPHAM

OS Grid Reference: TQ 040 085

Wepham is mentioned in the Domesday Book as 'Wocham', where a mill at 30*d* and two fisheries are recorded. In the early fifteenth century, a watermill paid rent, but there is no mention found in later records. This watermill was a tide mill,

Looking across the former Wepham tidal pond to the site of the tide mill at upper right.

which stood on the boundary brook on the eastern side of the ancient Burpham camp. There were traces of the mill in the seventeenth century.

On the site today is a Southern Water hut surrounded by trees and the millpond, which was called Wepham Mill Pond in 1656. This pond is known today as Shuttles Pond. The fields in the vicinity are still known as The Pells or Shuttles. The pond is tidal and the water runs underground at low tide. The area floods in wet weather.

WEST WITTERING

OS Grid Reference: SZ 773 986

West Wittering is mentioned in the Domesday Book as 'Westringes', where a mill is recorded. This mill, which yielded 30*d*, is thought to have been a tide mill as

The flooded marsh on the site of the West Wittering tidal pond.

there was no stream in the parish capable of working a watermill. The area is suitable to work a tide mill as the millpond could be filled up at each high tide. The tide mill was situated to the north-west of the church.

The mill is marked on the Spanish Armada map of 1587 as 'wittering mille', including the large millpond, which went north-west to south-east of the church. A 1647 survey mentions a field called 'Mill Pond Meadow', which abuts the churchyard. The tide mill went out of use in the sixteenth or seventeenth century. The sea has washed away any part of the mill, which is now under sand. All that remains today is The Marsh, which is the old millpond.

WORTHING: SEAMILL

OS Grid Reference: *c*. TQ 170 030

A tide mill existed in the sixteenth century at Seamill in the eastern part of Worthing. It was recorded in 1576 and was known as 'Sea Myll'. It may be on the site of a much earlier building going back centuries. The mill valued at 7s mentioned in the Domesday Book entry for Broadwater may have been the Seamill Tide Mill.

Possible site of Worthing Seamill Tide Mill, north of the A259 main road.

Possible site of Worthing Seamill Tide Mill, lost to the sea by coastal erosion.

The area of East Worthing where the Worthing Seamill once stood.

This tide mill used the flow of the tide into and out of the Broadwater. It probably stood near the Semells or Semmills Bridge, which was built in *c.* 1752. This bridge carried the Worthing to Lancing road, which was then further south. Seamill Farm was built in the area north of the road, which was named from the tide mill.

Erosion and changes to the coast line in the area makes it difficult to determine the site of the tide mill. It could either be north of the Brighton Road (A259) where there is a mound, or more likely lost to the sea by coastal erosion. At low tide, there are a group of large rocks, which may be the remains of the tide mill. This may not be the case because the coast is always changing.

It is possible that there may have been two tide mills at Seamill working in conjunction with each other. One of these could be the mound north of the road and the other lost to the sea by coastal erosion or another possible site to the east near Brooklands Lake where a mound may mark its site. Excavations are needed by future archaeologists before the site gets completely lost to the sea.

In Worthing's east field a 'Mill Furlong' was recorded in 1616 and 1635 and a 'Mill Field' in 1718. These names were thought to be named from an early windmill in the area, but could these names refer to the Seamill Tide Mill instead? The area north of the A259 has been built on during the twentieth century, including the site of Seamill Farm. The old track to the farm still remains. The name Seamill exists today in Seamill Park Avenue, Seamill Park Crescent, Seamill Way and a block of flats called Seamill Court.

POSSIBLE TIDE MILLS IN SUSSEX

There could be many more tide mills in Sussex waiting to be discovered. The area east of Eastbourne at Pevensey and Normans Bay are rich in misleading history. Pevensey was mentioned in the Domesday Book as 'Pevenesel', where a mill valued at 20s was recorded. This could have been a tide mill as the area was a marshy estuary at the time and the sea came up to the village. The sea is now some way to the south.

It is believed that some of the early Roman mill sites along this stretch of coast into Kent may well be tide mills. These sites are drawing attention to historians, archaeologists and molinologists into searching and investigating them. Some of them are probably lost beneath the waves.

The original town of Winchelsea, which was lost to the sea by coastal erosion in the thirteenth century, had lost about 300 houses, fifty pubs, two churches and mills. One or two of the latter may have been tidal. Nothing of the old town can be seen at low tide. In 1292 a new town of Winchelsea was built on Iham Hill.

The tidal River Ouse may have had tide mills downstream from Lewes. South Malling, Beddingham and Iford are mentioned in the Domesday Book, where mills are recorded in all three places. It is possible that some of these were tidal.

Possible site of Beddingham's Domesday mill, which may have been tidal.

That of Beddingham being a possibility. The site could be by the farm west of the church, and the low-lying land to the south may have been a millpond.

There are no known tide mills along the tidal River Adur and the mill mentioned in the Domesday Book for Applesham near Coombes was probably a watermill, which was fed by the Ladywell Stream. There is no place for a tidal millpond here. The medieval watermill at Shoreham was fed by the Northbourne Stream, which came of the original site of Shoreham Harbour. The site is somewhere near the Cemetery Lodge in Mill Lane. A tide mill was planned at Shoreham in the eighteenth century, but this was not built only part of the tidal millpond. The site would have been near the Ropetackle on the eastern side of the Adur.

Another possible tide mill could have existed at Lancing to the west of the Adur. Lancing is mentioned in the Domesday Book as 'Lancinges' where a mill valued at 8*s* is recorded. Was this mill tidal? It is recorded in the Nonae Returns for Lancing in 1341 that the tythe of a watermill was destroyed by the sea at 4*s* per annum. The site of this mill is probably out at sea south of Pende Hill. Could this also have been the site of the Domesday mill?

Another possible tide mill could be at Ferring west of Worthing. A watermill was lost to the sea by coastal erosion in the Middle Ages and its site is south of The Bluebird Café. The Ferring Rife, which is now no more than a drainage ditch today was a small inlet of the sea in Saxon times and for this reason could the mill

New Pond, 1330. Was this once a millpond for Ferring's possible tide mill, now lost to the sea by coastal erosion?

have been tidal? A large pond recorded as 'The New Pond' in 1330 to the east may have been a millpond.

There may have also been tide mills along the Arun Valley in Roman, Saxon and possibly medieval times. Lyminster between Littlehampton and Arundel was mentioned in the Domesday Book as Lolinminstre, where a mill at 5s was recorded. Could this mill have been tidal? A mill ditch was recorded in the village in 1412 and a manorial mill existed in 1461. The tidal estuary once came up to Lyminster Church.

Arundel Castle was mentioned in the Domesday Book as Castru Harundel where a mill, which paid 10 measures of wheat and 10 measures of rough corn, was recorded. It also mentions that Arundel Castle paid 40s from a mill in 1066. Offham near Arundel is mentioned in the Domesday Book as Offha where two mills are recorded belonging to the earl. Were any of these mills tidal? One of these mills was probably the watermill at Swanbourne. This mill may have once been tidal as there was a tidal inlet in the area at the time.

Further south in the Littlehampton area there were ancient mills at Wick and some of these may have also been tidal. These may have been situated on the tidal Black Ditch, which was a wide estuary at one time.

Tidal creeks also existed in the Bognor and Barnham areas and it is possible that there were tide mills here. Barnham was mentioned in the Domesday Book as 'Berneham' where a church and mill are recorded. Barnham was at one time a fishing village because a tidal creek came up to within a few yards of the church until the Middle Ages. This could mean that the mill may have been a tide mill. A tide mill may have existed at Felpham near Bognor, but this is awaiting confirmation.

There could have been other tide mills on Chichester Harbour and one of them may have been at Appledram or Appuldram near Chichester. A salt mill existed here until the nineteenth century, which was fed by the River Lavant. This river may have been tidal at Appledram in the Middle Ages and it is possible that a tide mill once existed here. Perhaps the salt mill was converted from a tide mill to a watermill. Bosham was mentioned in the Domesday Book as 'Boseham' where eleven mills with a total value of £14 10s and 4d and a church were recorded. Some of these mills may have been tidal. The existing Quay Mill watermill at Bosham was one of the Domesday mills. This mill is now in use as some other function.

Tide mills in Kent

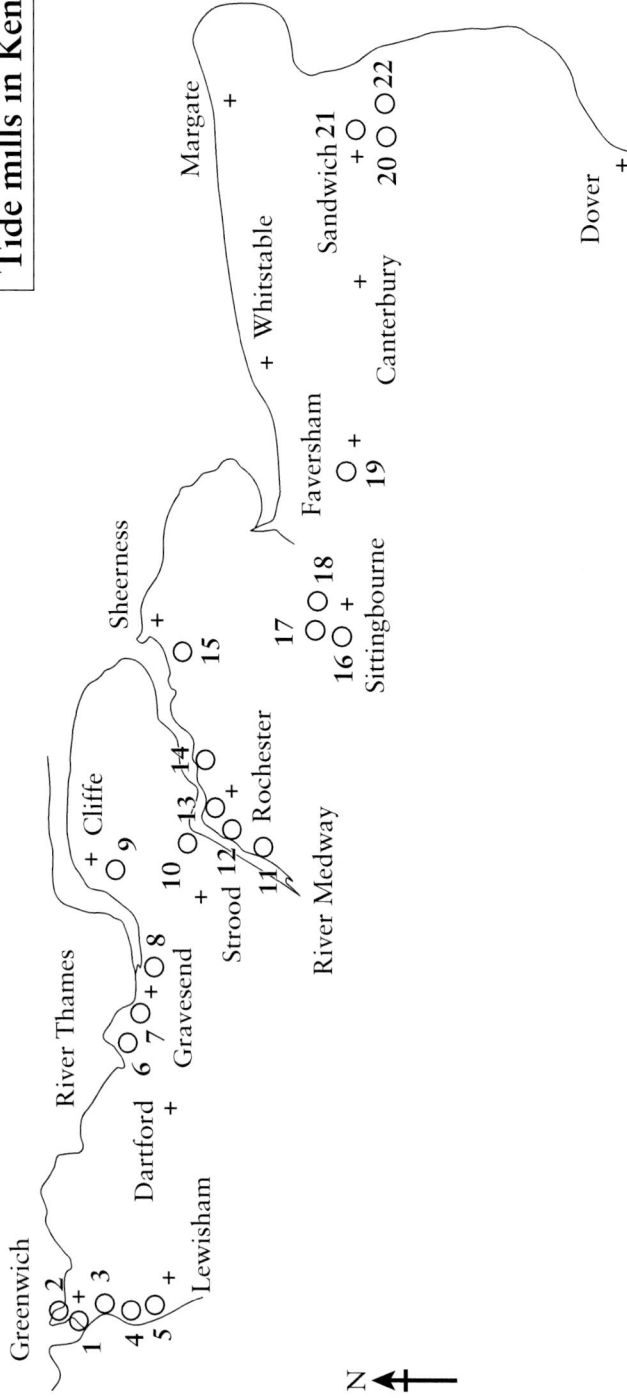

N ←

Greenwich
River Thames
Lewisham
Dartford
Gravesend
+ Cliffe
Sheerness
Margate
+ Whitstable
Faversham
Sandwich
Canterbury
Dover
River Medway
Strood
Rochester
Sittingbourne

1 2 3 4 5
6 7 + 8
9
10 13 14
12 15
11
16 17 18
19
20 21 22

1. Greenwich West
2. Greenwich East
3. Deptford: St Paul's Mill
4. Deptford: Flood Mill
5. Deptford: Brookmill
6. Ebbsfleet
7. Northfleet
8. Milton next Gravesend

9. Cliffe
10. Strood
11. Rochester: Borstal Mill
12. Rochester: St Nicholas Mill
13. Rochester: Priory Mill
14. Chatham
15. Queenborough
16. Milton Regis: Periwinkle Mill

17. Milton Regis: King's Mill
18. Sittingbourne
19. Faversham: Flood Mill
20. Sandwich
21. Stonar
22. Lydden

KENT

CHATHAM

OS Grid Reference: TQ 757 683

Chatham is mentioned in the Domesday Book as 'Ceteham' where a church, six fisheries and a mill valued at 32*d* are recorded. The tide mill at Chatham probably dates from Saxon times and it is marked on sixteenth- and seventeenth-century maps. The tide mill stood in The Brook area of Chatham where the Old Bourne River entered the Medway. A watermill was powered by The Brook near Luton Arches before the Norman Conquest.

Site of Chatham Tide Mill.

The millpond was partly fed from water of the Old Bourne River. The flow of water was controlled by floodgates and sluices. The tide mill came out of use in the 1740s and it was not marked on a 1765 map. The site of the tide mill was south of St Mary's Church and village. The River Medway was canalised. On the site of the tide mill today is an old pumphouse.

CLIFFE

OS Grid Reference: TQ 722 754

Cliffe on the Hoo Peninsula is mentioned in the Domesday Book as 'Clive', where a church is mentioned, but no mills. The tide mill at Westcliffe in Cliffe dates from the sixteenth century and in a 1549 lease there were two pieces of marsh in the area known as 'Myll Hoope'. These were situated between the tide mill and Cliffe Hill. One of the marshes was in Higham.

The tide mill was descsribed in a lease of 2 December 1611 as a corn mill (a tide mill), which had a wharf and millpond in Westcliffe, which is now known as West Court. This mill probably came out of use in the eighteenth century. The tide mill stood near West Court Farm. On the site today are cement works. There are no signs of the tide mill or millpond to be seen today.

DEPTFORD: BROOKMILL

OS Grid Reference: TQ 375 767

There is a plaque on Deptford Creek Bridge over the Deptford Creek on the River Ravensbourne stating many watermills were noted in the Domesday Book of 1086 nearby. These were recorded in the Lewisham entry where eleven were mentioned. Some of these were probably tidal. The plaque also states that the creek was first bridged here in 1804. This is Creek Road. Five mills are marked on Roque's map of 1745 between Deptford and Lewisham. The tidal creek of the Ravensbourne has been the site of three tide mills to grind corn into flour, which was brought here by barge.

Deptford Brookmill Tide Mill was one of the Domesday mills and situated on the River Ravensbourne south of Deptford Bridge. This mill was owned by the Crown and leased to a number of tenants and one being that of John Able in *c.* 1323. The mill was bought by John Evelyn (a London diarist) in 1668 and he used it for grinding colours.

In 1755 Brookmill was destroyed by fire and then it was rebuilt to grind flour and pump water. The mill closed later and was demolished. On the site today is a weir by the entrance to the Kent Waterworks. The name of the tide mill exists today in Brookmill Park and Brookmill Road on the west side of the Ravensbourne. Brookmill Park is now a nature reserve and recreation area with a lake called Brookmill Park Lake, which was once a reservoir.

Plaque on Deptford Creek Bridge depicting watermills on the River Ravensbourne at Deptford.

Site of the tide mill at Brookmill, Deptford, south of Deptford Bridge and millpond.

Deptford: Flood Mill

OS Grid Reference: TQ 373 772

Deptford Flood Mill was an ancient tide mill and probably one of the mills mentioned in the Domesday Book. It was known as 'Flood Mill' in 1293 and owned by Christ's Hospital in the seventeenth century. The mill was washed away during a flood in 1824 but was rebuilt in 1828 as Robinsons steam flour mills and comprised of four blocks. One of the blocks was Mumford's Mill on the other side of the creek, which was built in 1790.

The complex closed in the twentieth century and most of it was demolished in the 1970s after a fire. Nothing remains today apart from Mumford's Mill, which is now a block of flats. An old bus by The Birds Nest Inn (originally The Oxford Arms) in use as a restaurant occupies the tide mill site. It was situated north of Deptford Bridge. The Docklands Light Railway crosses the creek at this point.

Site of Deptford Flood Mill. The large building, which was Mumford's Mill, is now a block of flats.

Watercolour of Deptford Tide Mill.
(David Plunkett Collection)

Site of Deptford Flood Mill where the Birds Nest pub now stands.

DEPTFORD: ST PAUL'S MILL

OS Grid Reference: TQ 375 775

This tide mill was the northernmost of the three Deptford tide mills. It was probably one of the Domesday mills. It was also known as King's Mill and situated on the Deptford Creek near Creekside, east of St Paul's Church. The tide mill closed in the nineteenth century and was demolished. There are no remains to be seen today. In the area south of St Paul's Church, a road called Tidemill Way and Old Tidemill School is named from the old tide mill.

EBBSFLEET (NORTHFLEET)

OS Grid Reference: TQ 607 754

Before the construction of the High Speed 1 railway, excavations of an Anglo-Saxon tide mill were carried out by Oxford Archaeology and Wessex Archaeology. The excavation report was in *Settling the Ebbsfleet Valley, High Speed 1*

Excavations of the Anglo-Saxon Ebbsfleet (Northfleet) Tide Mill carried out by Oxford Archaeology and Wessex Archaeology. (Copyright Oxford Wessex Archaeology)

excavations at Springhead and Northfleet, Kent: the Late Iron Age, Roman and Anglo-Saxon Landscape, Volume 1: The sites. The mill was found deep in the old Ebbsfleet Stream in Northfleet.

The tide mill dates from the seventh century AD and was constructed mainly of wood. It had good timbers with a horizontal waterwheel. It is the earliest of its kind found in Britain and this makes it a very important discovery. This tide mill was not in use for very long. There are no remains on the site today. Some of the recovered oak timbers have been conserved at Chatham Historic Dockyard.

There is an Anglo-Saxon charter from *c.* AD 687 or 688 that says that 'Swanscombe and Erith' (the mill lies on the Swanscombe side of the Ebbsfleet) was held by the nunnery at Barking Abbey, having been granted to them by Eorcenwold, Bishop of the east Saxons (Electronic Sawyer S1246). The lands were apparently originally granted to the nunnery by King Aethelred of Mercia, possibly following his campaign against the kingdom of Kent in AD 676, and the resulting sack of Rochester.

FAVERSHAM: FLOOD MILL

OS Grid Reference: TR 012 616

Faversham is mentioned in the Domesday Book as 'Favreshant', where two salt houses at 3*s* 2*d* and a mill at 20*s* are recorded, but no church. This mill

Site of Faversham Flood Mill, which became Twymans Mill, is now a block of flats.

may have been a tide mill. The tide mill known as 'Flood Mill' dates from the medieval period and may be on the site of the Domesday mill. It was situated at the head of Faversham Creek at the end of Flood Lane. This lane is named from the tide mill.

This tide mill was adjacent to the later Chart Gunpowder Mills, which were built in the sixteenth century. It was probably linked to them. On the site of the tide mill today is a building called Twymans Mill, which is now a block of flats. The old millpond was fed from a sluice from the creek. It is the lowest of the millponds and the only one still surviving today. It is called Stonebridge Pond.

The gunpowder mills were one of the earliest gunpowder mills in the UK. There were a total of four. They closed in 1934 and only one of them still stands today, which is open to the public. It is a scheduled ancient monument and it is the only surviving complete gunpowder mill in Britain.

GREENWICH: EAST

OS Grid Reference: TQ 398 792

Greenwich is mentioned in the Domesday Book as 'Grenviz', where four mills at 70s are recorded, but no church. Some of these mills may have been tidal. The tide mill at East Greenwich was built from 1804, on the site of an earlier brick fields. It was a new capital intensive, major engineering construction, designed to operate both with inward and outward tides. There were four linked tidal ponds in use.

The tide mill seems to have been successful for about ten years and then slowly went out of use. In the 1840s Frank Hills acquired the site as part of his marriage settlement to Ellen Rawlings. There were good wharfage facilities in the area. The tide mill was described as a steam mill in about 1845 meaning that it was replaced by a 25 hp steam engine by this time.

Housing was built near the mill in River Way in the 1840s for Frank Hill's workers. These were added to Ceylon Place, which was built in 1801. The mill site was converted to industrial use and finally closed in the twentieth century and was demolished. On the site today is parkland. The cottages in River Way are still there and Ceylon Place is now a pub known as The Pilot. The area of the tide mill site has been redeveloped in the early part of the twenty-first century.

GREENWICH: WEST

OS Grid Reference: TQ 391 784

The tide mill at West Greenwich was probably one of the four mills mentioned in the Domesday Book. The later tide mill on this site dates from the twelfth century and was on Greenwich Wharf. It had a vertical wheel in 1194. The tide mill was

Excavations of the Greenwich West Tide Mill by the Museum of London Archaeology (MOLA) in 2008/2009. (Courtesy of Museum of London Archaeology)

Site of Greenwich West Tide Mill.

probably built by the Lewisham House of the Abbey of St Peter of Ghent. This and other buildings were here from 918 until 1414. The tide mill probably came out of action and demolished sometime in the fifteenth century.

The Museum of London Archaeology (MOLA) undertook an excavation on the site in 2008/2009 and again in 2012. They found the remains of the tide mill, which was well preserved. Large timber beams, floor framing, chalk foundations and fragments of millstones were found. The timber base of the wheel pit was dug out and remains of the waterwheel were found. All of these finds were taken to Yorkshire for conservation and research. The site of the tide mill is now built over by modern development in an area known as 'Granite wharf'. There are no remains of the tide mill on the site.

LYDDEN

OS Grid Reference: TR 349 576

The tide mill at Lydden near Sandwich dates from the late thirteenth century. It had a very short life due to great storm damage in 1316 and was moved to a new site by the Priory in 1317. This tide mill was damaged by high tides sometime

Site of Lydden Tide Mill, Sandwich.

later and was abandoned in 1326. The tide mill was taken down and re-erected at Fordwich. There are no visible remains on the original sites today. The tide mill probably stood north of Sandown Road east of Newcut Bridge where there is a dip in the field and the millpond was south of the road.

MILTON-NEXT-GRAVESEND

OS Grid Reference: TQ 654 743

Milton-next-Gravesend was mentioned in the Domesday Book as 'Meletune', where a church and a mill valued at 49*d* are recorded. Was this mill tidal? The tide mill was probably built in the Middle Ages and possibly closed a couple of centuries ago. It was situated near the River Thames, east of Gravesend. There are no visible remains of this tide mill to be seen today.

Site of Milton-next-Gravesend Tide Mill.

MILTON REGIS: KING'S MILL

OS Grid Reference: TQ 903 645

Milton Regis near Sittingbourne was mentioned in the Domesday Book as 'Middeltune', where twenty-seven salt houses at 27*s*, thirty-two fisheries at 22*s* and 8*d* and six mills at 30*s* are recorded. The place was once just called Middleton. One or more of these Domesday mills may have been tide mills situated along the Milton Creek.

King's Mill was probably one of the Domesday mills. It came out of use sometime in the early twentieth century. There are no signs of the mill to be seen and on the site today is modern housing. The name of the mill exists today in Kings Mill Close. There is a dip in the area, which was once the millpond. This area floods in very wet weather.

Site of Milton Regis King's Mill, now built over.

MILTON REGIS: PERIWINKLE MILL

OS Grid Reference: TQ 902 644

This tide mill is known as Periwinkle Mill and was named from the nearby stream. It is probably one of the Domesday mills. For some years, this mill also manufactured pearl barley, which was imported from Holland. It is said that this is the only mill in Britain that brought it to the same perfection as Holland.

The mill came out of use in the early part of the twentieth century. Most of it was demolished in 1970 and all that remains of the mill today are bits of walling, millstones and the waterwheel in a built-up area. The wheel is being restored and a museum is planned to be built around the mill site to preserve it. This is the only remaining watermill in the area. Periwinkle Close runs alongside the mill.

Remains of the Milton Regis Periwinkle Tide Mill, showing the waterwheel.

NORTHFLEET: WYATT'S MILL

OS Grid Reference: TQ 618 749

Northfleet was mentioned in the Domesday Book as 'Norfluet' where a church, fishery and a mill valued at 10s are recorded. This mill may have been tidal. The existing tide mill dates from the post-medieval period and was in operation in the latter part of the seventeenth century. The tide mill was mentioned in 1679/80 and was part of the possessions of the see of Canterbury.

The tide mill was a timber-framed building, which later became a stucco mill. The mill came out of use in the nineteenth century and the site was lost to cement works and modern development. Its location was near the mouth of the River Fleet near the Thames north of Northfleet station. Only the millpond and mill race remains today in an industrial estate. It was planned to rebuild the mill as part of restoration by the Northfleet Harbour Restoration Trust in the future, but this never happened.

Site of Northfleet Wyatt's Mill millpond in an area that is now industrial.

Site of the castle and tide mill at Queenborough. The castle is visible as an earthwork.

QUEENBOROUGH

OS Grid Reference: TQ 912 722

This tide mill was a fourteenth-century new build with Queenborough Castle. The castle was built by Edward III in the fourteenth century and also incorporated the tide mill. This small mill used the castle moat as a tidal pond. Ships were unloading at the tide mill on the wharf in 1373 and some probably brought corn to the mill to grind into flour and exported it. The castle was demolished with the mill in the mid-seventeenth century. All that remains on the site today are the earthworks of the castle and the well.

ROCHESTER: BORSTAL MILL

OS Grid Reference: TQ 717 665

Rochester is mentioned in the Domesday Book as 'Rovecestre', but no churches or mills are recorded. Borstal south of the city was also mentioned in the Domesday

Site of Rochester Borstall Tide Mill.

Book as 'Borchetelle' where two mills at 20*s* are recorded. One or both of these mills may have been tidal. Borstal is derived from Anglo-Saxon *burg-steall*, meaning 'fort site' or 'place of refuge'.

The ancient mill at Borstal is believed to be a tide mill, which belonged to the see of Rochester in 1323. It was rebuilt by Hamo de Hethe in the same year. It probably came out of use in the seventeenth century. Its site is situated somewhere on the eastern side of the River Medway, south-west of the M2 Medway Bridge. There are no remains of the tide mill to be seen today.

ROCHESTER: PRIORY MILL

OS Grid Reference: TQ 745 687

This tide mill dates from the Middle Ages. It came out of use and was demolished sometime during the seventeenth century. The tide mill stood near the city walls at the end of George Lane, just outside the city walls. The medieval cellars of the George Inn in the High Street are said to have served in conjunction with the tide mill.

Site of Rochester Priory Tide Mill, near the railway viaduct.

The railway viaduct by Corporation Street (A2 main road) may well be on the site of the tide mill. The area was called 'The Marshe' on John Speed's map of 1610. There are no signs of the tide mill to be seen today.

ROCHESTER: ST NICHOLAS MILL

OS Grid Reference: TQ 739 685

This tide mill dates from the medieval period. It was situated under the castle on the eastern banks of the Medway, south of the medieval road bridge. It was

Site of St Nicholas Tide Mill, near Rochester Castle.

a double tide mill in about 1650. It came out of use sometime in the late seventeenth or early eighteenth century. There are no visible remains of the tide mill today.

SANDWICH

OS Grid Reference: TR 331 574

Sandwich is mentioned in the Domesday Book as 'Sandwice', but no church or mills are recorded. The tide mill at Sandwich dates from the fourteenth century. A mill stood on the Delf in 1488, which was powered by fresh water, but was powered by salt water by 1538. A Mr Adrian was employed to build another mill in 1562 on a site locally, which the Mayor and Jurats had chosen.

A mill field was owned by St Bartholomew's Hospital in the fourteenth century, which was to the south-east of the hospital. There were several tidal mills at

The Delf, Sandwich. Possible site of an early tide mill.

Sandwich Guestling Mill (now a house), possibly on the site of one of the tide mills.

Sandwich on the Wantsum Channel in the Middle Ages. These were either washed away, blown away or burnt down. The existing watermill, Guestling Mill (now a house), was probably built on the site of or near one of the tide mills. There are no signs of these tide mills today.

SITTINGBOURNE

OS Grid Reference: TQ 905 644

The tide mill at Sittingbourne dates from the Middle Ages and it was known as 'Fluddmill' in the sixteenth century. It was situated on the Milton Creek. The mill was described as a tide and steam mill in a sale ad in 1838. It was a four-storey brick building and worked four pairs of stones.

The tide pool, which fed the mill race, gave concern in 1861. It had become a mass of mud, sedge and decaying vegetation during that time. The mill closed

Site of Sittingbourne Tide Mill in an industrial estate.

in the nineteenth century and a warehouse called 'Tidal Mill Warehouse' was built on the site. This is near the Sittingbourne and Kemsley light railway station.

STONAR

OS Grid Reference: TR 335 612

The ancient town and port of Stonar was mainly inundated by the sea in the thirteenth century, but its main destruction was by French attacks in the fourteenth century. Two watermills were burnt down in 1266, which belonged to the abbott of St Augustine's. These were at Stonar and Effsfleete (now Ebbsfleet). The watermill at Ebbsfleet may have been a tide mill. There was also a mill at Hippilisflete in the latter part of the thirteenth century. None of these mills exist today.

The tide mill at Stonar dates from the medieval period. It probably came out of use when the town was lost. The tide mill site including the tidal pond is now silted up. Great Stonar Lake is on the site of the old town and probably the tide mill. Ebbsfleet, Stonar and nearby Richborough were once on the Kent coast (Wantsum Channel) but are now inland.

Site of the lost town and tide mill at Stonar.

One of two millstones in the grounds of the Saxon Shore Fort at Richborough. Were they from a watermill or possibly a tide mill?

Romano-British millstones were found at Richborough from an old watermill or possibly a tide mill. One of the millstones was made of Kentish Ragstone. They are on display in the grounds of the Saxon Shore Fort of Richborough. It is also possible that these millstones may have come from the Roman mill site, inland at Ickham, which was not tidal.

STROOD: HORSENAILS MILL

OS Grid Reference: TQ 740 690

The tide mill at Strood on the opposite side of the River Medway from Rochester dates from the early medieval period. The mill belonged to Temple Strood Manor and it had two mills under one roof in the mid-fourteenth century. There were two undershot waterwheels. The tide mill was able to produce about fifty sacks of flour per week. Six working hours were possible at spring tides.

In its latter days, the tide mill worked up to five pairs of millstones and finally a steam engine was installed to enable the mill to work for longer periods. It ceased work in 1858 and was demolished. On the site today is Water Mill Wharf, which is situated to the north of the railway bridge. Some steps called 'Watermill Stairs' were built in the area. The Watermill Tavern (now Watermill House) stands on the site of the miller's house. A watermill sign exists on the house.

Site of Strood Tide Mill at Watermill Stairs.

Watermill House sign on the former Watermill Tavern at Strood. This was the site of the miller's house.

POSSIBLE TIDE MILLS IN KENT

There could be many more tide mills in Kent waiting to be discovered. One of these could have been at Dover. Dover was mentioned in the Domesday Book as 'Dovera', where three churches and two mills are recorded. One of these mills may well have been a tide mill as it is described as 'wrecks almost all ships through its great disturbance of the sea'. There is no proof that Dover ever had a tide mill within the old inner harbour, but there were two watermills on the Doure River. Some historians believe a watermill may have stood at the entrance to Dover Harbour for a short period.

A tide mill may have existed at Folkestone. This place was mentioned in the Domesday book as 'Fulchestan' where five churches, one salthouse and eleven and a half mills are recorded with a total value of £11 12s and 35d. Some of these mills may have been tidal. The half mill may have been a watermill, which spanned a river where one part of it was in another parish.

Other possible tide mills may have been at Burham. This village was mentioned in the Domesday Book as 'Borham', where a church and a mill valued at 6s are recorded. This mill is lost and would have been situated on the River Medway to the west of the village. Was this mill tidal? Another case could be at Wouldham further up the River Medway (on the tidal limits), but its history is doubtful. Wouldham is mentioned in the Domesday Book as 'Oldeham', where a church and one fishery are recorded, but no mills. Another tide mill may have been at

Site of the possible tide mill at Wouldham.

Cuxton on the River Medway near Rochester. This village was mentioned in the Domesday Book as 'Coclestane' where a church and a mill valued at 30*d* are recorded. Was this mill tidal?

There could have been a tide mill on the coastal inlet or creek near Reculver on the north Kent coast. It is possible that this may well have been a Roman tide mill. There is a reference to a charter of AD 949 to a 'mill-floet'. This is considered to be an early reference to a tidal mill in the area. This would have been east of the Saxon Shore Fort and ruins of Reculver Church. Reculver is mentioned in the Domesday Book as 'Roculf' where a church, five salt houses at 64*d*, a fishery and a mill valued at 25*d* are recorded. Could this mill have been tidal?

There may have been other tide mills situated on the creeks along the north Kent coast. One of these may have been at Rainham east of Gillingham. The site was probably on Rainham Creek south of Motney Hill. Rainham was not mentioned in the Domesday Book and the mill's history is doubtful. Another tide mill could have been at Oare north of Faversham, which was mentioned in the Domesday Book as 'Ore' where one and a half churches and a mill valued at 22*s* are recorded. Was this mill tidal? Another tide mill may have existed at Graveney north-east of Faversham on or near the Graveney Marshes. This village was mentioned in the Domesday Book as 'Gravenel' where four salt houses were recorded, but no mill.

A tide mill may have existed at Hoo St Werburgh on the Hoo Peninsula. This place was mentioned in the Domesday Book as 'Hov', where six churches, two fisheries valued at 5*s* and a mill valued at 10*s* are recorded. This mill may have been tidal.

Other tide mills may have existed on the Thames estuary in the Dartford area. Dartford is mentioned in the Domesday Book as 'Tarentefort', where three churches and two mills are recorded with no values. Were any of these tide mills? Other places in the vicinity may also have had tide mills like Swanscombe, Greenhithe, Erith and Woolwich. Swanscombe and Woolwich are mentioned in the Domesday Book, but no mills are recorded.

There may have been tide mills in the Appledore and Stone in Oxney area where inlets and creeks once existed there. Appledore was mentioned in the Domesday Book as 'Apeldres' where two churches, six fisheries and a mill valued at 2*s* are recorded. This mill may well have been a tide mill.

BIBLIOGRAPHY

Allcroft, A., *Waters of Arun* (Metheun and Co. Ltd, 1930)

Barton, N., *The Lost Rivers of London* (Quality Paper Backs, 1992)

Blakeney, R., *Fishbourne: A Village History* (Rita Blakeney, 1984)

Caws, S., *The Isle of Wight: A Pictorial History* (Phillimore, 1989)

Day, G., *Tide Mills in England and Wales* (Friends of Woodbridge Tide Mill, 1994)

Ellis, M., *Water and Wind Mills in Hampshire and the Isle of Wight* (Southampton University Archaeology Group, 1978)

Emsworth Maritime and Historical Trust, *Mills and Millers* (Emsworth Paper No. 5, 2003)

Evans, A., 'A Countryman's Diary' (*Sussex County Magazine*, 1941), pp. 354–59

Gregory, F. and Martin, R., *Sussex Watermills* (SB Publications, 1997)

Holyoake, G. and Burnham, T., *Kent Windmills and Watermills* (The Dovecote Press Ltd, 2012)

Insole, A. and Parker, A., *Industrial Archaeology on the Isle of Wight* (County Museum Publications No. 3, 1979)

Lyndhurst, D., *Bishopstone and the Lost Village of Tide Mills* (SB Publications, 2008)

Major, J. K., *The Mills of the Isle of Wight* (Charles Shilton Ltd, 1970)

Major, J. K. and Watts, M., *Victorian and Edwardian Watermills and Windmills* (The Dovecote Press Ltd, 2012)

Minchinton, W., *Tide Mills of England and Wales* (1977)

Moore, P., *A Guide to The Industrial Archaeology of Hampshire and the Isle of Wight* (Southampton University Industrial Archaeology Group, 1984)

Moore, P., *Bygone Fareham* (Phillimore, 1990)

Pelham, R. A., *The Old Mills of Southampton* (Southampton Papers Number Three, Southampton Corporation, 1963)

Ramzan, D., *Greenwich Through Time* (Amberley Publishing, 2010)

Reger, J., *Chichester Harbour: A History* (Phillimore, 1996)

Reid, K. C., *Watermills of the London Countryside: Their Place in English Landscape and Life, Vol. 1* (Charles Skilton Ltd, 1987)

Smith, D., *The Tide Mill at Eling: History of a Working Mill* (Ensign Publications, 1989)

Stidder, D. and Smith, C., *Watermills of Sussex. Volume I – East Sussex* (Baron Birch, 1997)

Stidder, D. and Smith, C., *Watermills of Sussex. Volume II – West Sussex* (Derek Stidder and Colin Smith, 2001)

Syson, L., *British Watermills* (B T Batsford Ltd, 1965)

Syson, L., *The Watermills of Britain* (David and Charles, 1980)

Vaidya, A., *The Mills and Millers of Hampshire. Vol 1: Central* (Hampshire Mills Group, 2011)

Vaidya, A., *The Mills and Millers of Hampshire. Vol 2: West* (Hampshire Mills Group, 2012)

Vince, J., *Discovering Watermills* (Shire Publications, 1987)

Vincent, A., 'Seamill Tide Mill: Worthing', *TIMS Newsletter*, No. 94 (June 2017), p. 46)

Wailes, R., *A Source Book of Windmills and Watermills* (Ward Lock Ltd, 1979)

Wailes, R., *Tide Mills, Part 1. No. 2* (SPAB, 1938)

Wailes, R., *Tide Mills, Part 2, No. 3* (SPAB, 1956)

Watts, M., *The Archaeology of Mills and Milling* (Tempus Publishing, 2002)

Watts, M., *Water and Wind Power* (Shire Publications, 2005)

Watts, M., *Watermills* (Shire Publications Ltd, 2006)

Weaver, M., *The Tide Mill Woodbridge* (Friends of Woodbridge Tide Mill, 1993)

Acknowledgements

I wish to thank all who have helped me in preparing this book – museums, libraries, record offices, mill groups, friends and others. Particular thanks go to David Plunkett, Martin Snow and Charles Walker for their help. A special thank you also goes to those who have given me permission to use old photographs, sketches, watercolours and photographs of excavations from their archives.